D0287331

THE TRANSFORMATION OF
NATURE IN ART

THE TRANSFORMATION
OF NATURE IN ART

BY

ANANDA K. COOMARASWAMY

DOVER PUBLICATIONS

New York

This Dover edition, first published in 1956, is an unabridged and unaltered republication of the second edition, as published by the Harvard University Press in 1934.
This edition is published by special arrangement with Harvard University Press.

International Standard Book Number: 0-486-20368-9

Manufactured in the United States of America
Dover Publications, Inc.
180 Varick Street
New York, N.Y. 10014

Contents

Chapter I

THE THEORY OF ART IN ASIA

Chapter I

THE THEORY OF ART IN ASIA

Tadbhavatu krtârthatâ vaidagdhyasya,
Mālatīmādhava, I, 32 f.

IN THE following pages there is presented a statement of Oriental aesthetic theory based mainly on Indian and partly on Chinese sources; at the same time, by means of notes and occasional remarks, a basis is offered for a general theory of art coördinating Eastern and Western points of view. Whenever European art is referred to by way of contrast or elucidation, it should be remembered that "European art" is of two very different kinds, one Christian and scholastic, the other post-Renaissance and personal. It will be evident enough from our essay on Eckhart, and might have been made equally clear from a study of St Thomas and his sources, that there was a time when Europe and Asia could and did actually understand each other very well. Asia has remained herself; but subsequent to the extroversion of the European consciousness and its preoccupation with surfaces, it has become more and more difficult for European minds to think in terms of unity, and therefore more difficult to understand the Asiatic point of view. It is just possible that the mathematical development of modern science, and certain corresponding

tendencies in modern European art on the one hand, and the penetration of Asiatic thought and art into the Western environment on the other, may represent the possibility of a renewed *rapprochement*. The peace and happiness of the world depend on this possibility. But for the present, Asiatic thought has hardly been, can hardly be, presented in European phraseology without distortion, and what is called the appreciation of Asiatic art is mainly based on categorical misinterpretations. Our purpose in the present volume is to place the Asiatic and the valid European views side by side, not as curiosities, but as representing actual and indispensable truth; not endeavoring to prove by any argumentation what should be apparent to the consciousness of the intelligent — *sacetasām anubhavaḥ pramāṇam tatra kevalam!*

The scope of the discussion permits only a brief reference to Muḥammadan art: Islāmic aesthetics could be presented only by an author steeped in Arabic philosophy and familiar with the literature on calligraphy, poetics, and the legitimacy of music. But it must be pointed out in passing that this Islāmic art, which in so many ways links East with West, and yet by its aniconic character seems to stand in opposition to both, really diverges not so much in fundamental principles as in literal interpretation. For naturalism is antipathetic to religious art of all kinds, to art of any kind, and the spirit of the traditional Islāmic interdiction of the representation of living forms is not really infringed by such ideal representations as are met with in Indian

or Christian iconography, or Chinese animal painting. The Muhammadan interdiction refers to such naturalistic representations as could theoretically, at the Judgment Day, be required to function biologically; but the Indian icon is not constructed as though to function biologically, the Christian icon cannot be thought of as moved by any other thing than its form, and each should, strictly speaking, be regarded as a kind of diagram, expressing certain ideas, and not as the likeness of anything on earth.

Let us now consider what is art and what are the values of art from an Asiatic, that is, mainly Indian and Far Eastern, point of view. It will be natural to lay most stress on India, because the systematic discussion of aesthetic problems has been far more developed there than in China, where we have to deduce the theory from what has been said and done by painters, rather than from any doctrine propounded by philosophers or rhetoricians.

In the first place, then, we find it clearly recognized that the formal element in art represents a purely mental activity, *citta-saññā*.[1] From this point of view, it will appear natural enough that India should have developed a highly specialized technique of vision. The maker of an icon, having by various means proper to the practice of Yoga eliminated the distracting influences of fugitive emotions and creature images, self-willing and self-thinking, proceeds to visualize the form of the *devatā*, angel or aspect of God, described in a given canonical prescription, *sādhana, mantram, dhyāna*. The mind "pro-duces" or "draws"

(*ākarṣati*)[2] this form to itself, as though from a great distance. Ultimately, that is, from Heaven, where the types of art exist in formal operation; immediately, from "the immanent space in the heart" (*antar-hṛdaya-ākāśa*),[3] the common focus (*saṁstāva*, "concord")[4] of seer and seen, at which place the only possible experience of reality takes place.[5] The true-knowledge-purity-aspect (*jñāna-sattva-rūpa*) thus conceived and inwardly known (*antar-jñeya*) reveals itself against the ideal space (*ākāśa*) like a reflection (*pratibimbavat*), or as if seen in a dream (*svapnavat*). The imager must realize a complete self-identification with it (*ātmānaṁ . . . dhyāyāt,* or *bhāvayet*), whatever its peculiarities (*nānālakṣaṇâlaṁkṛtam*), even in the case of opposite sex or when the divinity is provided with terrible supernatural characteristics; the form thus known in an act of non-differentiation, being held in view as long as may be necessary (*evaṁ rūpaṁ yāvad icchati tāvad vibhāvayet*), is the model from which he proceeds to execution in stone, pigment, or other material.[6]

The whole process, up to the point of manufacture, belongs to the established order of personal devotions, in which worship is paid to an image mentally conceived (*dhyātvā yajet*); in any case, the principle involved is that true knowledge of an object is not obtained by merely empirical observation or reflex registration (*pratyakṣa*), but only when the knower and known, seer and seen, meet in an act transcending distinction (*anayor advaita*). To worship any Angel in truth one must become the Angel: "whoever

worships a divinity as other than the self, thinking 'He is one, and I another,' knows not," *Bṛhadāraṇyaka Upaniṣad*, I, 4, 10.

The procedure on the part of the imager, above outlined, implies a real understanding of the psychology of aesthetic intuition. To generalize, whatever object may be the artist's chosen or appointed theme becomes for the time being the single object of his attention and devotion; and only when the theme has thus become for him an immediate experience can it be stated authoritatively from knowledge. Accordingly, the language of Yoga may be employed even in the case of a portrait, for example *Mālavikâgnimitra*, II, 2, where, the painter having missed something of the beauty of the model, this is attributed to a relaxation of concentration, an imperfect absorption, *śithila-samādhi*, not to want of observation. Even when a horse is to be modelled from life we still find the language of Yoga employed: "having concentrated, he should set to work" (*dhyātvā kuryāt*), *Śukranītisāra*, IV, 7, 73.

Here indeed European and Asiatic art meet on absolutely common ground; according to Eckhart, the skilled painter shows his art, but it is not himself that it reveals to us, and in the words of Dante, "Who paints a figure, if he cannot be it, cannot draw it," *Chi pinge figura, si non può esser lei, non la può porre.*[7] It should be added that the idea of Yoga covers not merely the moment of intuition, but also execution: Yoga is dexterity in action, *karmasu kauśala*, *Bhagavad Gītā*, II, 50. So, for example, in Śaṅkarâcārya's meta-

phor of the arrow-maker "who perceives nothing beyond
his work when he is buried in it," and the saying, "I have
learnt concentration from the maker of arrows." The
words *yogyā*, application, study, practice, and *yukti*, ac-
complishment, skill, virtuosity, are often used in connec-
tion with the arts.

An ideal derivation of the types that are to be represented
or made by the human artist is sometimes asserted in an-
other way, all the arts being thought of as having a divine
origin, and as having been revealed or otherwise brought
down from Heaven to Earth: "our Śaiva Āgamas teach
that the architecture of our temples is all Kailāsabhāvanā,
that is of forms prevailing in Kailāsa." A very striking
enunciation of this principle will be found in *Aitareya
Brāhmaṇa*, VI, 27: "It is in imitation (*anukṛiti*) of the
angelic (*deva*) works of art (*śilpāni*) that any work of art
(*śilpa*) is accomplished (*adhigamyate*) here; for example, a
clay elephant, a brazen object, a garment, a gold object,
and a mule-chariot are 'works of art.' A work of art
(*śilpa*), indeed (*ha*), is accomplished in him who compre-
hends this. For these (angelic) works of art (*śilpāni*, viz.
the metrical Śilpa texts) are an integration of the Self
(*ātma-saṃskṛti*); and by them the sacrificer likewise inte-
grates himself (*ātmānaṃ saṃskurute*) in the mode of rhythm
(*chandomaya*)." Corresponding to this are many passages
of the *Ṛg Veda* in which the artistry of the incantation
(*mantra*) is compared to that of a weaver or carpenter.
Sometimes the artist is thought of as visiting some heaven,

and there seeing the form of the angel or architecture to be reproduced on earth; sometimes the architect is spoken of as controlled by Viśvakarma, originally an essential name of the Supreme Artificer, later simply of the master architect of the angels, and patron of human craftsmen; or Viśvakarma may be thought of as himself assuming the form of a human architect in order to produce a particular work; or the required form may be revealed in a dream.[8]

Nor is any distinction of kind as between fine and decorative, free or servile, art to be made in this connection. Indian literature provides us with numerous lists of the eighteen or more professional arts (*śilpa*) and the sixty-four avocational arts (*kalā*); and these embrace every kind of skilled activity, from music, painting, and weaving to horsemanship, cookery, and the practice of magic, without distinction of rank, all being equally of angelic origin.[9]

It is thus, and will become further, evident that all the forms of Indian art and its derivatives in the Far East are ideally determined. We must now give greater precision to this statement, discussing what is implied in Asia by likeness or imitation, and what is the nature of Asiatic types. Lastly we shall be in a position to consider the formal theory of aesthetic experience.

First of all with regard to representation (*ākṛti, sādṛśya*, Ch. *hsing-ssŭ*, 4617, 10289, and *wu-hsing*, 12777, 4617) and imitation (*anukāra, anukaraṇa, anukṛti*). We find it stated that "*sādṛśya* is essential to the very substance (*pradhāna*) of painting," *Viṣṇudharmottara*, XLII, 48; the word has

usually been translated by "likeness," and may bear this
sense, but it will be shown below that the meaning properly
implied is something more like "correspondence of formal
and representative elements in art." In drama we meet
with such definitions as *lokavṛtta-anukaraṇa*, "following the
movement (or operation) of the world," and *yo 'yaṁ
svabhāvo lokasya . . . nāṭyam ity abhidhīyate*,[10] "which
designates the intrinsic nature of the world"; or again,
what is to be exhibited on the stage is *avasthāna*, "condi-
tions" or "emotional situations," or the hero, Rāma, or
the like, is thought of as the model, *anukārya*.[11] In China,
in the third canon of Hsieh Ho, we have "According to
nature (*wu*, 12777) make shape (*hsing*, 4617)"; [12] and the
common later phrase *hsing-ssŭ*, "shape-resemblance," in
the same way seems to define art as an imitation of Nature.
In Japan, Seami, the great author and critic of Nō, asserts
that the arts of music and dancing consist entirely in imi-
tation (*monomane*).[13]

However, if we suppose that all this implies a conception
of art as something seeking its perfection in the nearest
possible approaches to illusion we shall be greatly mis-
taken. It will appear presently that we should err equally
in supposing that Asiatic art represents an "ideal" world,
a world "idealized" in the popular (sentimental, religious)
sense of the words, that is, perfected or remolded nearer
to the heart's desire; which were it so might be described
as a blasphemy against the witness of Perfect Experience,
and a cynical depreciation of life itself. We shall find that

Asiatic art is ideal in the mathematical sense: like Nature (*natura naturans*), not in appearance (viz. that of *ens naturata*), but in operation.

It should be realized that from the Indian (metaphysical) and Scholastic points of view, subjective and objective are not irreconcilable categories, one of which must be regarded as real to the exclusion of the other. Reality (*satya*) subsists there where the intelligible and sensible meet in the common unity of being, and cannot be thought of as existing in itself outside and apart from, but rather *as*, knowledge or vision, that is, only in act. All this is also implied in the Scholastic definition of truth as *adaequatio rei et intellectus*, Aristotle's identity of the soul with what it knows, or according to St Thomas, "knowledge comes about in so far as the object known is within the knower" (*Sum. Theol.*, I, Q. 59, A. 2), in radical contradiction to the conception of knowledge and being as independent acts, which point of view is only logically, and not immediately, valid. Translating this from psychological to theological terms, we should say not that God has knowledge, but that Knowledge (Pure Intellect, *prajñā*) is one of the names of God (who is pure act); or metaphysically, by an identification of Being (*sat*) with Intelligence (*cit*), as in the well-known concatenation *sac-cit-ānanda* (where it is similarly implied that love subsists only in the act of love, not in the lover or beloved but in union).

Now as to *sādṛśya*: literal meanings are sym-visibility, con-similarity; secondary meanings, coördination, analogy.

That aesthetic *sādṛśya* does not imply naturalism, veri-
similitude, illustration, or illusion in any superficial sense
is sufficiently shown by the fact that in Indian lists of
factors essential to painting it is almost always mentioned
with *pramāṇa*, "criterion of truth," here "ideal propor-
tion"; in the Indian theories of knowledge empirical obser-
vation (*pratyakṣa*) as supplying only a test, and not the
material of theory, is regarded as the least valid amongst
the various *pramāṇas*. *Pramāṇa* will be discussed more
fully below; here it will suffice to point out that the con-
stant association of *sādṛśya* and *pramāṇa* in lists of the
essentials in painting, for example the Six Limbs,[14] pre-
cludes our giving to either term a meaning flatly contra-
dicting that of the other. Ideal form and natural shape,
although distinct in principle, were not conceived as in-
commensurable, but rather as coincident in the common
unity of the symbol.

In Rhetoric, *sādṛśya* is illustrated by the example "The
young man is a lion" (Bhartṛmitra, *Abhidhā-vṛtti-mātrikā*,
p. 17, and commonly quoted elsewhere); and this analogy
very well demonstrates what is really meant by aesthetic
"imitation." Vasubandhu, *Abhidharmakośa*, IX, Poussin,
pp. 280, 281, explains the relation of knowledge (*vijñāna*)
to its object by saying that knowledge arises only in the act
of knowing, by an immediate assimilation (*tadākāratā*) to
its object, neither knower nor known existing apart from
the act of knowledge. The nature of the assimilation (*tadā-
kāratā*) is illustrated by the *sādṛśya* of seed and fruit, which

is one of reciprocal causality. The Nyāya-Vaiśeṣika defini-
tion of *sādṛśya* (quoted by Das Gupta, *History of Indian
Philosophy*, I, 318) viz. *tadbhinnatve sati tadgata-bhūyodhar-
mavattvam*, is literally "the condition of embracing in itself
things of a manifold nature which are distinct from itself,"
or more briefly the condition of "identity in difference."

Sādṛśya is then "similitude," but rather such as is im-
plied by "simile" than by "simulacrum." It is in fact
obvious that the likeness between anything and any repre-
sentation of it cannot be a likeness of nature, but must be
analogical or exemplary, or both of these. What the repre-
sentation imitates is the idea or species of the thing, by
which it is known intellectually, rather than the substance
of the thing as it is perceived by the senses.

Sādṛśya, "visual correspondence," has nevertheless been
commonly misinterpreted as having to do with two appear-
ances, that of the work of art and that of the model. It
refers, actually, to a quality wholly self-contained within
the work of art itself, a correspondence of mental and sen-
sational factors in the work. This correspondence is indeed
analogous to the correspondence of person and substance
in the thing to be "imitated"; but the object and the work
of art are independently determined, each to its own good,
and physically incommensurable, being the same only as
to type. *Sādṛśya* as the ground (*pradhāna*) of painting may
be compared to *sāhitya* as the body (*śarīra*) of poetry, con-
sistently defined as the "consent of sound and meaning"
(*śabdârtha*), and to *sārūpya*, denoting the aspectual coördi-

nation of concept and percept essential to knowledge.[15]
Accordingly, the requirement of *sādṛśya* does not merely
not exclude the formal element in art, but positively asserts
the necessity of a concord of pictorial and formal elements.
The whole point of view outlined above is already implied
in the *Kauṣītaki Upaniṣad*, III, 8, where the sensational
and intelligible (formal) elements of appearance are dis-
tinguished as *bhūta-mātrā* and *prajñā-mātrā*, and it is as-
serted that "truly, from either alone, no aspect (*rūpa*)
whatsoever would be produced."

As to the Indian drama, the theme is exhibited by means
of gestures, speech, costume, and natural adaptation of the
actor for the part; and of these four, the first three are
highly conventional in any case, while with regard to the
fourth not only is the appearance of the actor formally
modified by make-up or even a mask, but Indian treatises
constantly emphasize that the actor should not be carried
away by the emotions he represents, but should rather be
the ever-conscious master of the puppet show performed by
his own body on the stage, The exhibition of his own emo-
tions would not be art.[16]

As to Chinese *wu-hsing* and *hsing-ssŭ*, a multitude of
passages could be adduced to show that it is not the
outward appearance (*hsing*) as such, but rather the idea
(*i*, 5367) in the mind of the artist, or the immanent divine
spirit (*shên*, 9819), or the breath of life (*ch'i*, 1064), that is
to be revealed by a right use of natural forms. We have
not merely the first canon of Hsieh Ho, which asserts that

the work of art must reveal "the operation (*yün*, 13817) of the spirit (*ch'i*) in life-movement," but also such sayings as "By means of natural shape (*hsing*) represent divine spirit (*shên*)," "The painters of old painted the idea (*i*) and not merely the shape (*hsing*)," "When Chao Tze Yün paints, though he makes few brush-strokes, he expresses the idea (*i*, 5367) already conceived; mere skill (*kung*, 6553) cannot accomplish (*nêng*) this" (*Ostasiatische Zeitschrift*, NF. 8, p. 105, text 4), or with reference to a degenerate period, "Those painters who neglect natural shape (*hsing*) and secure the formative idea (*i chih*, 5367, 1783) are few," "What the age means by pictures is resemblance (*ssŭ*)," and "The form was like (*hsing-ssŭ*), but the expression (*yün*, 13843) weak."

The Japanese Nō, which "can move the heart when not only representation but song, dance, mimic, and rapid action are all eliminated, emotion as it were springing out of quiescence," is actually the most formal and least naturalistic of all kinds of drama in the world.

Thus none of the terms cited by any means implies a view of art as finding its perfection in illusion; for the East, as for St Thomas, *ars imitatur naturam in sua operatione.*

The principle most emphasized in Indian treatises as essential to art is *pramāṇa.*[17] The Indian theories of knowledge regard as the source of truth not empirical perception (*pratyakṣa*) but an inwardly known model (*antarjñeya-rūpa*) "which at the same time gives form to knowledge and is the cause of knowledge" (Dignāga, *kārikā* 6), it being only

required that such knowledge shall not contradict experience. It will be realized that this is also the method of science, which similarly uses experiment as the test rather than as the source of theory. *Pramāṇa* as principle is the self-evident immediate (*svataḥ*) perception of what is correct under given conditions. As independent of memory, *pramāṇa* cannot be identified with authority, but it may embody elements derived from authority, when considered not as principle but as canon. As not contrary to experience, *pramāṇa* means what is "true" here and now, but might not be correct in the light of wider experience or under changed conditions; in other words, the "development" of a theory is not excluded, nor the development of a design while in the course of execution. The doctrine can also be made clearer by the analogy of conscience, Anglo-Saxon "inwit," still understood as an inward criterion which at the same time gives form to conduct and is the cause of conduct. But whereas the Occidental conscience operates only in the field of ethics, and as to art a man is not ashamed to say "I know what I like," the Oriental conscience, *pramāṇa*, cf. Chinese *chih*, 1753, *liang*, 7015, *chêng*, 720 (used by Hsüan Tsang), *i*, 5367, etc., governs all forms of activity, mental, aesthetic, and ethical (*speculabilium, factibilium, agibilium*). Truth, Beauty, and Love as activities and therefore relative, are thus connected by analogy, and not by likeness, none deriving its sanction from any other, but each from a common principle of order inherent in the nature of God, or in Chinese terms of Heaven

and Earth. To sum up, *pramāṇa* means in philosophy the norm of properly directed thought, in ethics the norm of properly directed action, in art the norm of properly conceived design, practically the *recta ratio factibilium* of St Thomas.

Thus the idea of *pramāṇa* implies the existence of types or archetypes, which might at first thought be compared with those of Plato and the derived European tradition. But whereas Platonic types are types of being, external to the conditioned universe and thought of as absolutes reflected in phenomena, Indian types are those of sentient activity or functional utility conceivable only in a contingent world. Oriental types, Indian Śiva-Śakti, Chinese Yang and Yin, or Heaven and Earth, are not thought of as mechanically reflected in phenomena, but as representing to our mentality the operative principles by which we "explain" phenomena — just as, for example, the concept of the shortest distance between two points may be said to "explain" the existence of a perceptible straight line. Thus Indian types representing sentiences or powers are analogous to those of Scholastic theology and the energies of science, but not comparable with Plato's types.

Just as conscience is externalized in rules of conduct, or the principles of thought in logic, so aesthetic *pramāṇa* finds expressions in rules (*vidhi, niyama*), or canons of proportion (*tāla, tālamāna, pramāṇāni*), proper to different types, and in the *lakṣaṇas* of iconography and cultivated taste, prescribed by authority and tradition; and only

that art "which accords with canonical standards (*śāstra-māna*) is truly lovely, none other, forsooth!" (*Śukranī-tisāra*, IV, 4, 105–106). As to the necessity for such rules, contingent as they are by nature, and yet binding in a given environment, this follows from the imperfection of human nature as it is in itself. Man is indeed more than a merely instinctive and behavioristic animal, but he has not yet attained to such an identification of the inner and outer, contemplative and active, life as should enable him to act at the same time without discipline and altogether conveniently. On the one hand, the gambolling of lambs, however charming, is not yet dancing; on the other, the human artist, even the master whom Ching Hao calls "Profound" or "Mysterious" (*miao*, 7857) and who "works in a style appropriate to his subject," can hardly lay claim to the spontaneity of the "Divine" (*shên*, 9819) painter "who makes no effort of his own, his hand moves spontaneously."[18]

There exists, in fact, dating from the T'ang period, a threefold Chinese classification (*San p'ing*, 9552, 9273) of painting as Divine (*shên*, 9819), Profound or Mysterious (*miao*, 7857), and Accomplished (*nêng*, 8184). The first of these implies an absolute perfection; representing rather the goal than the attainable in human art; the second is such mastery as approaches perfection, the third is mere dexterity. A fourth class, the Marvellous or Extraordinary (*i*, 5536), was added later, with Taoist implications, to denote a more personal kind of "philosophical" or "literary" painting, great in achievement, though not the work

of professional artists, and not governed by traditional rules; *i* thus corresponds very nearly to what is meant by "genius," with all its virtues and limitations.[19]

A striking Indian parallel to the *San p'ing* occurs in Rājaśekhara's *Kāvya-mīmāṁsā*, Ch. II, where the creative faculty (*kārayitrī pratibhā*) is considered as of three kinds, viz. Innate (*sahajā*), Gotten (*āhāryā*), and Learnt (*aupadeśikā*), poets being correspondingly classed as *sārasvata* (from Sarasvatī, Śakti of Brahmā, and mother of learning and wisdom), *ābhyāsika* (trained, adept, vocational), and *aupadeśika* (taught, depending on rules or recipes). Here *sārasvata* and *sahaja* clearly correspond to *shên*; *āhāryā* and *ābhyāsika* to *miao*, involving the idea of mastery; and *aupadeśikā* to *nêng*, having a trick rather than a habit. The one thing most necessary to the human workman is *abhyāsa*, "practice," otherwise thought of as *anuśīla*, "devoted application" or "obedience," the fruit of which is *śliṣṭatva*, "habitus," or second nature, skill, lit. "clingingness," "adherence"; and this finds expression in the performance as *mādhurya*, "grace" or "facility" (*Nāṭya Śāstra*, Benares ed., XXVI, 34; *Kāvyamālā* ed., XXII, 34).

The Six Canons of Hsieh Ho, referring to painting, were first published in the fifth century, and have remained authoritative to the present day. They have been discussed at great length by Far Eastern and European authors, the chief differences of opinion centering on the Taoist or Confucian interpretation of the first canon.[20] The following version is based directly on the text:

(1) Operation or revolution (*yün*, 13817), or concord or reverberation (*yün*, 13843), of the spirit (*ch'i*, 1064) in life movement.

(2) Rendering of the "bones" (essential structure) by the brush.

(3) According to the object (natural species, *wu*, 12777) make shape (*hsing*, 4617).

(4) According to the kind, apply, or distribute, color.

(5) Right composition, lit. "design due-placing."

(6) Traditional (*ch'uan*, 2740) procedure, lit. "handed down model, or method, draw accordingly."

Of these canons, the first is of primary metaphysical importance, and may be said to control all the others, each of which taken by itself has a straightforward meaning. The second canon demands a rendering of character rather than of mere outward aspect; the third and fourth refer to mass and color as means of representation; the fifth refers to the proper and appropriate placing of things represented, according to their natural relationships, and must thus be distinguished from composition or design in the sense in which these words are now used; the last implies the copying of ancient masterpieces and adherence to wonted methods and ascertained rules. These Six Canons have close analogies in Indian theory, but there is no good reason to suppose that they are of Indian origin.

In connection with the last canon, it may be remarked that a condition of spontaneity (*shên*, *sahaja*) outside of and above ascertained rules, though not against them, can

be imagined, as in the *Bhagavad Gītā*, II, 46, where the knower of Brahman is said to have no further use for the Vedas, or when St Augustine says, "Love God, and do what you will." But if the liberated being (*jīvanmukta*) or saint in a state of grace is thus free to act without deliberation as to duty, it is because for him there no longer exists a separation of self and not-self; if for the true Yogin *pratyakṣa* must imply a presentation indistinguishable from that of the inwardly known form (*jñāna-sattva-rūpa*), this will be evidence, not of genius, but of a fully matured self (*kṛtātman*), a perfected visual habit, such that the seer now sees not merely projected sensations, but as he ought to see, virtually without duality, loving all things alike.

All art thus tends towards a perfection in which pictorial and formal elements are not merely reconciled, but completely identified. At this distant but ever virtually present point, all necessity for art disappears, and the Islāmic doctors are justified in their assertion that the only true artist (*muṣavvir*) is God, in Indian terms *nirmāṇa-kāraka*.

The metaphor of God as the supreme artist appears also in the Christian Scholastic tradition, for example St Thomas, *Sum. Theol.*, Q. 74, A. 3, "as the giving form to a work of art is by means of the form of the art in the mind of the artist, which may be called his intelligible word, so the giving form to every creature is by the word of God; and for this reason in the works of distinction and adornment the Word is mentioned . . . the words, *God saw that it was good* . . . express a certain satisfaction taken by God in

his works, as of an artist in his art." Eckhart makes con-
stant use of the same idea. Cf. notes 21, 57. Needless to
point out, the concept of "creation" (*nirmāṇa, karma*) is a
religious (*bhaktivāda*) translation of what in metaphysics
is spoken of as manifestation, procession, or expression
(*sṛṣṭi*); or psychologically simply as a "coming to be"
(*utpāda, bhava, yathā-bhūta*, etc.), dependent on second or
mediate causes.

As the author of the *Chieh Tzŭ Yüan* expresses it, "When
painting has reached divinity (*shên*) there is an end of the
matter." A conception of this kind can be recognized in
the Chinese story of the painter Wu Tao-tzŭ, who painted
on a palace wall a glorious landscape, with mountains, for-
ests, clouds, birds, men, and all things as in Nature, a veri-
table world-picture; while the Emperor his patron was ad-
miring this painting, Wu Tao-tzŭ pointed to a doorway on
the side of a mountain, inviting the Emperor to enter and
behold the marvels within. Wu Tao-tzŭ himself entered
first, beckoning the Emperor to follow; but the door closed,
and the painter was never seen again. A corresponding dis-
appearance of the work of art, when perfection has been
attained, is mythically expressed in other legends, such as
those of painted dragons that flew from the walls on which
they were painted, first told of the artist Chang Sêng Yu
in the Liang Dynasty.[21]

Such is the perfection toward which art and artist tend,
art becoming manifested life, and the artist passing beyond
our ken. But to lay claim therefore to a state of liberty and

superiority to discipline (*anācāra*) on behalf of the human
artist, to idolize one who is still a man as something more
than man, to glorify rebellion and independence, as in the
modern deification of genius and tolerance of the vagaries
of genius, is plainly preposterous, or as Muslims would say
blasphemous, for who shall presume to say that he indeed
knows Brahman, or truly and completely loves God? The
ultimate liberty of spontaneity is indeed conceivable only
as a workless manifestation in which art and artist are per-
fected; but what thus lies beyond contingency is no longer
"art," and in the meantime the way to liberty has nothing
whatever in common with any wilful rebellion or calculated
originality; least of all has it anything to do with functional
self-expression. Ascertained rules should be thought of as
the vehicle assumed by spontaneity, in so far as sponta-
neity is possible for us, rather than as any kind of bondage.
Such rules are necessary to any being whose activity depends
on will, as expressed in India with reference to the drama:
"All the activities of the angels, whether at home in their
own places, or abroad in the breaths of life, are intellectu-
ally emanated; those of men are put forth by conscious
effort; therefore it is that the works to be done by men are
defined in detail," *Nāṭya Śāstra*, II, 5. As expressed by
St Thomas (*Sum. Theol.*, I, Q. 59, A. 2), "there alone are
essence and will identified where all good is contained
within the essence of him who wills . . . this cannot be
said of any creature." In tending toward an ultimate co-
incidence of discipline and will, the artist does indeed be-

come ever less and less conscious of rules, and for the virtuoso intuition and performance are already apparently simultaneous; but at every stage the artist will delight in rules, as the master of language delights in grammar, though he may speak without constant reference to the treatises on syntax. It is of the essence of art to bring back into order the multiplicity of Nature, and it is in this sense that he "prepares all creatures to return to God."

It should be hardly necessary to point out that art is by definition essentially conventional (*saṁketita*); for it is only by convention that nature can be made intelligible, and only by signs and symbols, *rūpa*, *pratīka*, that communication is made possible. A good example of the way in which we take the conventionality of art for granted is afforded by the story of a famous master who was commissioned to paint a bamboo forest. With magnificent skill he painted entirely in red. The patron objected that this was unnatural. The painter enquired, "In what color should it have been painted?" and the patron replied, "In black, of course." "And who," said the artist, "ever saw a black-leaved bamboo?" [22]

The whole problem of symbolism (*pratīka*, "symbol") is discussed by Śaṅkarâcārya, Commentary on the *Vedânta Sūtras*, I, 1, 20. Endorsing the statement that "all who sing here to the harp, sing Him," he points out that this Him refers to the highest Lord only, who is the ultimate theme even of worldly songs. And as to anthropomorphic expressions in scripture, "we reply that the highest Lord may,

when he pleases, assume a bodily shape formed of Māyā, in order to gratify his devout worshippers"; but all this is merely analogical, as when we say that the Brahman abides here or there, which in reality abides only in its own glory (cf. *ibid.*, I, 2, 29). The representation of the invisible by the visible is also discussed by Deussen, *Philosophy of the Upanishads*, pp. 99–101. For a discussion of "sign" and "symbol" see pp. 125–127.

Conventionality has nothing to do with calculated simplification (as in modern designing), or with degeneration from representation (as often assumed by the historians of art). It is unfortunate indeed that the word conventional should have come to be used in a deprecatory sense with reference to decadent art. Decadent art is simply an art which is no longer felt or energized, but merely denotes, in which there exists no longer any real correspondence between the formal and pictorial elements, its meaning as it were negated by the weakness or incongruity of the pictorial element; but it is often, as for example in late Hellenistic art, actually *far less* conventional than are the primitive or classic stages of the same sequence. True art, pure art, never enters into competition with the unattainable perfection of the world, but relies exclusively on its own logic and its own criteria, which cannot be tested by standards of truth or goodness applicable in other fields of activity. If, for example, an icon is provided with numerous heads or arms, or combines anthropomorphic and theriomorphic elements, arithmetic and observation will assist us to de-

termine whether or not the iconography is correct (*āgamâr-thâvisaṁvādi, śāstramāna*), but only our own response to its qualities of energy and characteristic order will enable us to judge it as a work of art. If Kṛṣṇa is depicted as the seducer of the milkmaids of Braja, it would be ridiculous to raise objections on moral grounds, as though a model on the plane of conduct had been presented; for here art, by a well understood convention, deals with the natural relation of the soul to God ("all creation is female to God"), and if we cannot understand or will not accept the tradition, that is simply an announcement of our inability to pass aesthetic judgment in the given case.

Some further considerations upon unequal quality and decadence in art may be submitted, by decadence "characteristic imperfection" being meant rather than the opposite of "progress." Any lack of temporal perfection in a work of art is a betrayal of the imperfection of the artist, such perfection as is possible to human work being a product of the will. It is obvious that the workman's first consideration should have been the good of the work to be done, for it is only so that he can praise his theme; and as to whether the work is in this sense good, we ought to be guided by a proper and ruthless critical faculty. But it should not be overlooked that even in outwardly imperfect works, whether originally so or having become so through damage, the image may remain intact; for in the first case the image, which was not of the artist's own invention but inherited, can still be recognized in its imperfect embodiment, and in the sec-